COLORING BOOK

this book belongs to

VICTORIA

VICTORIA

Illustrations and design © 2016 [VICTORIA]
All rights reserved.
Published by CreateSpace Independent Publishing Platform

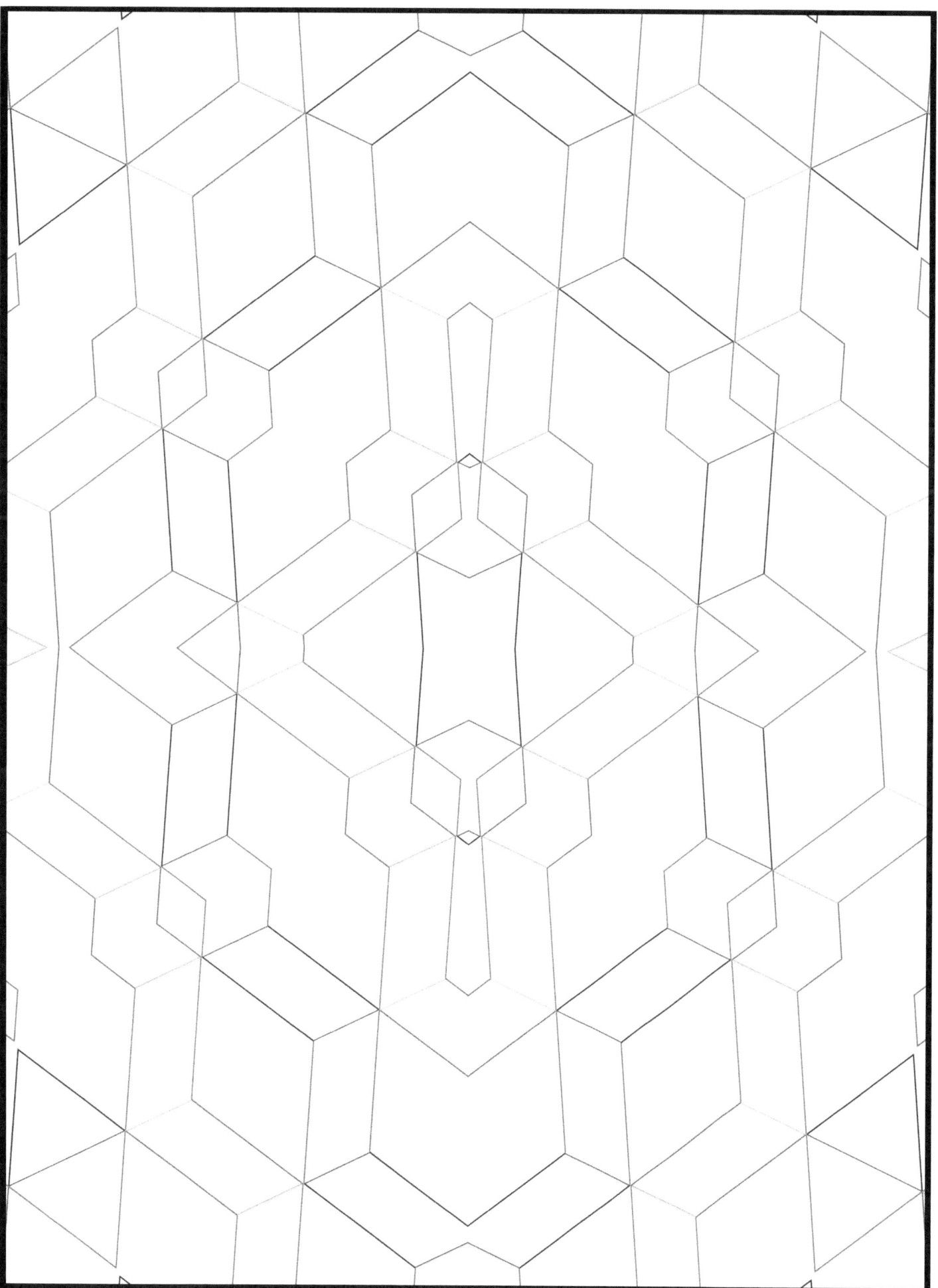

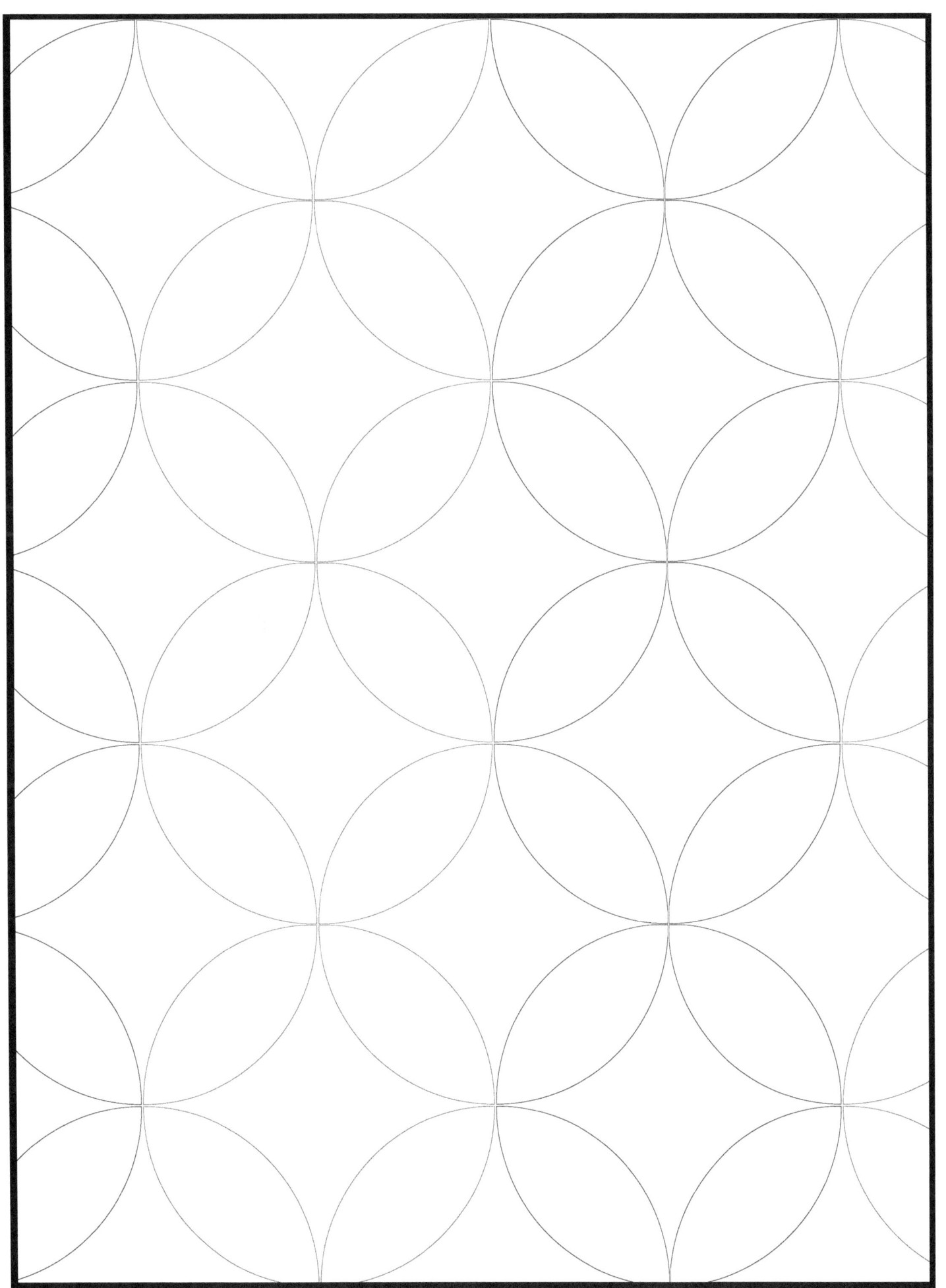

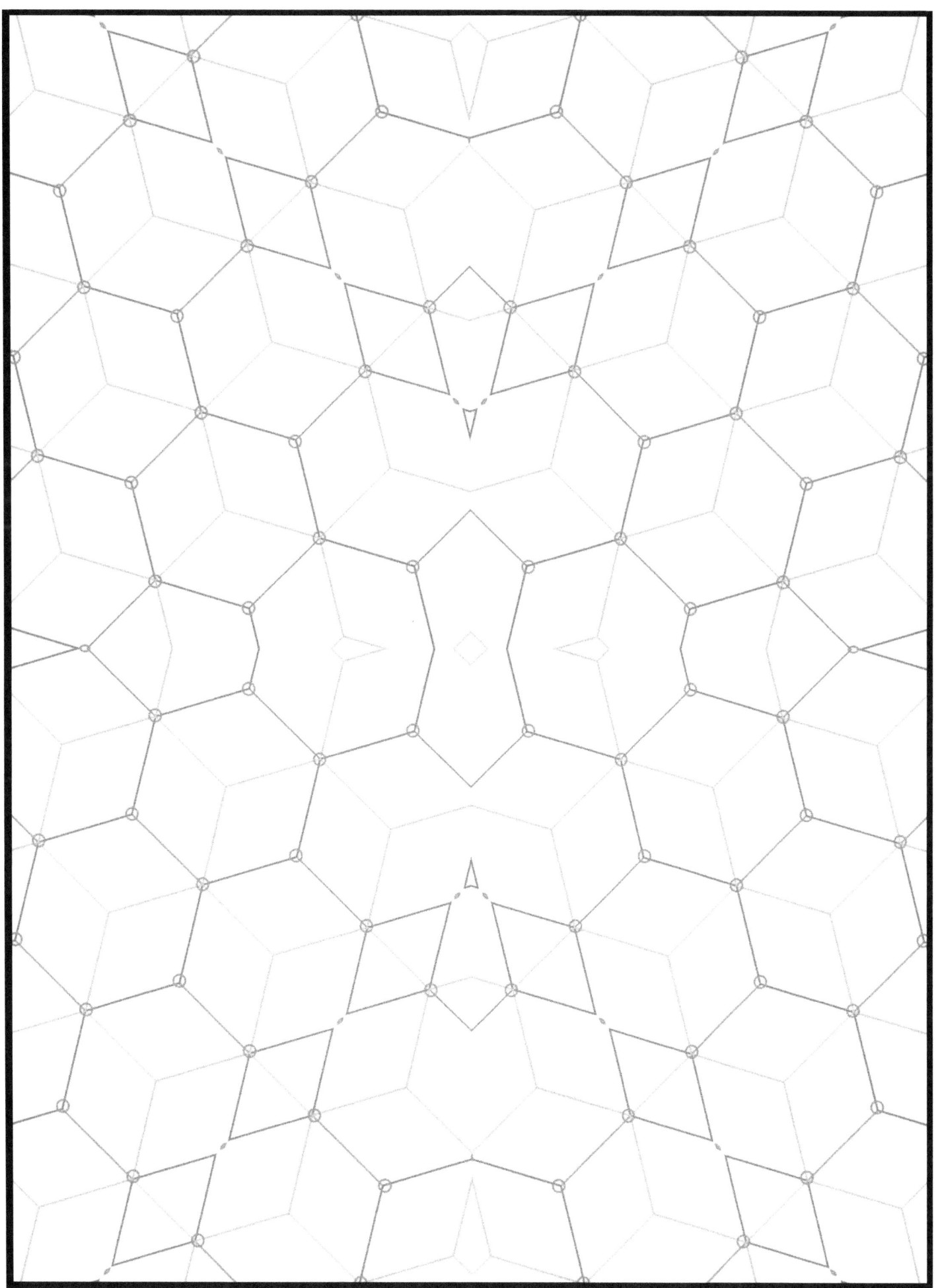

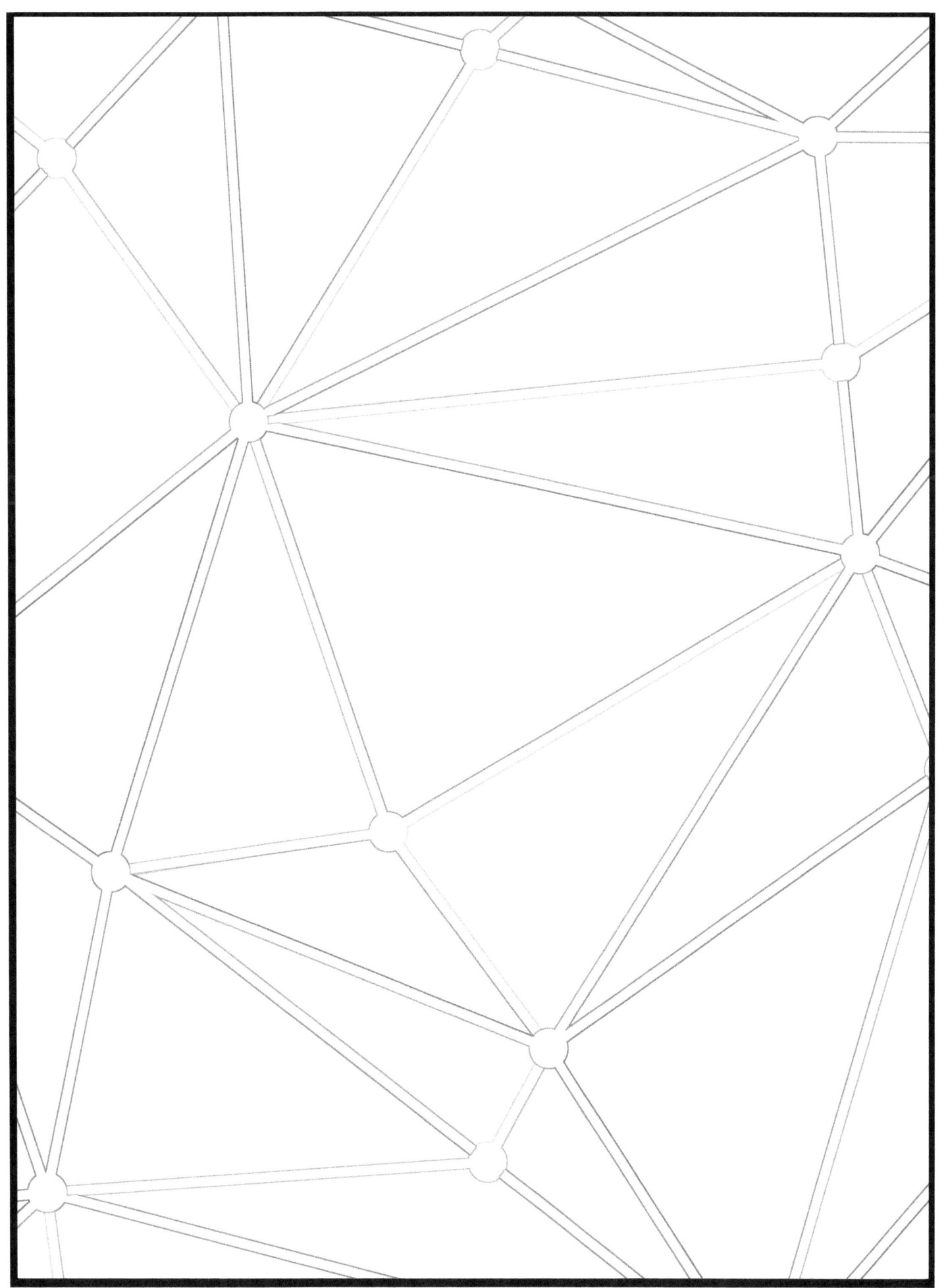

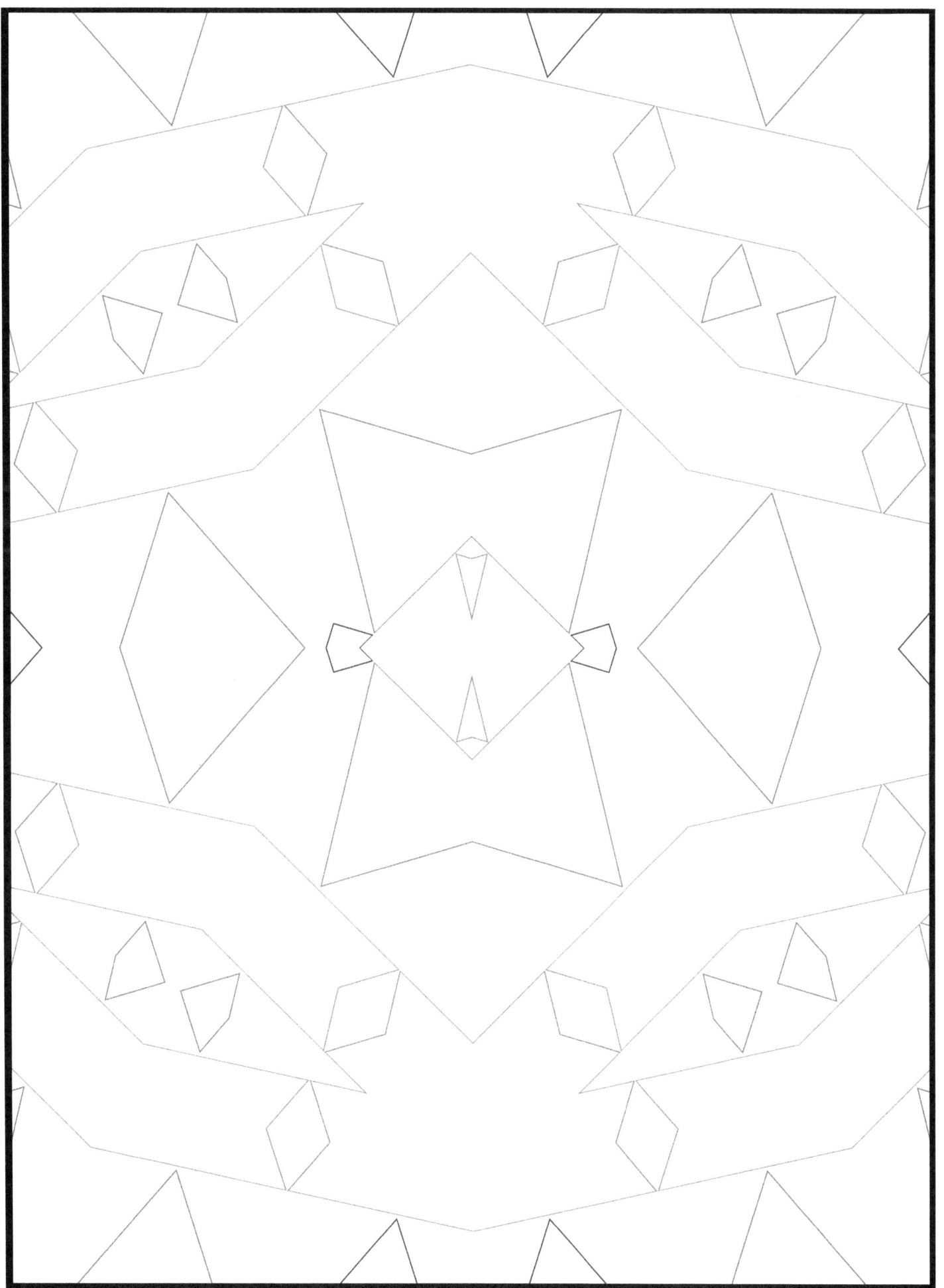

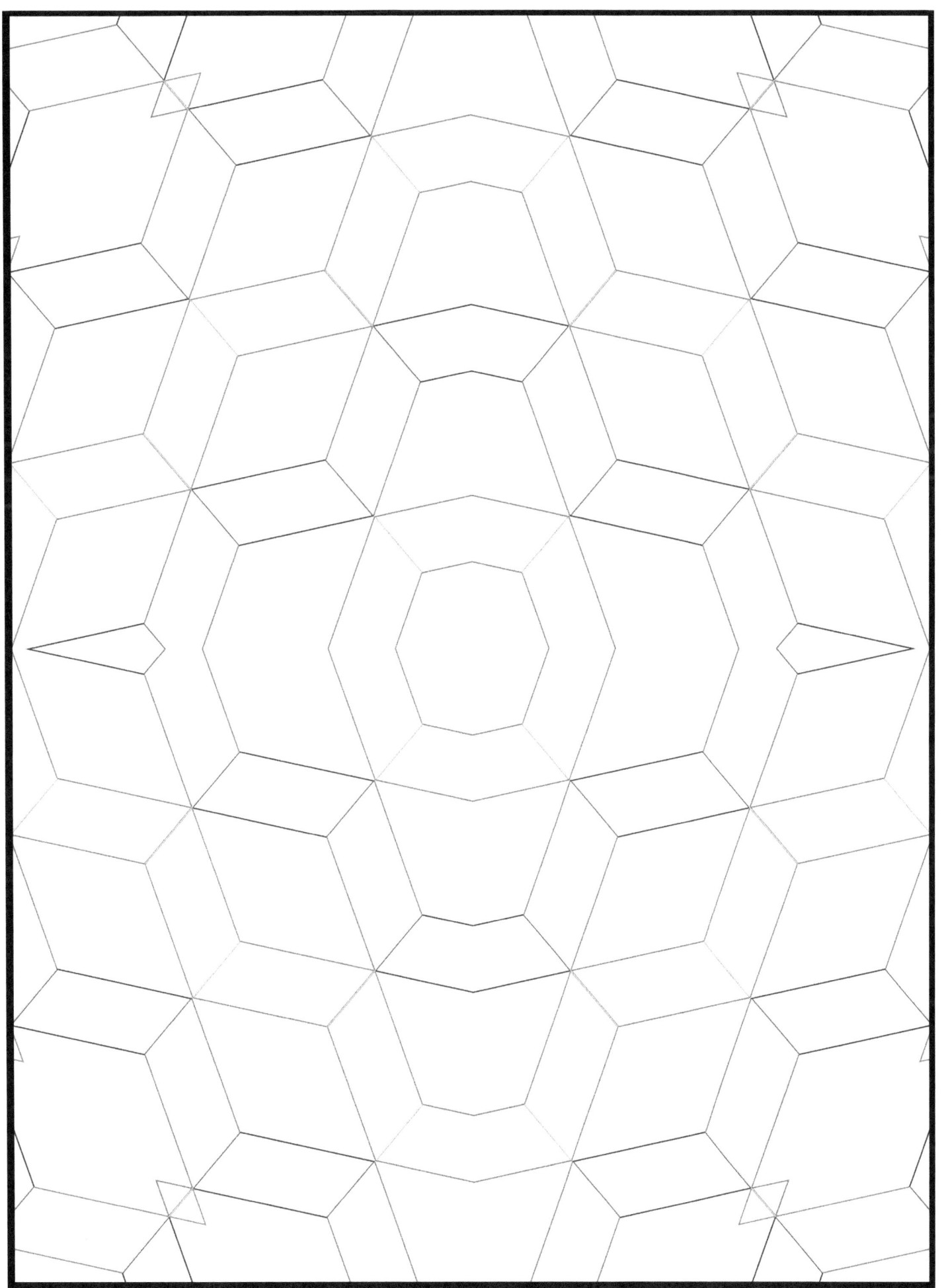

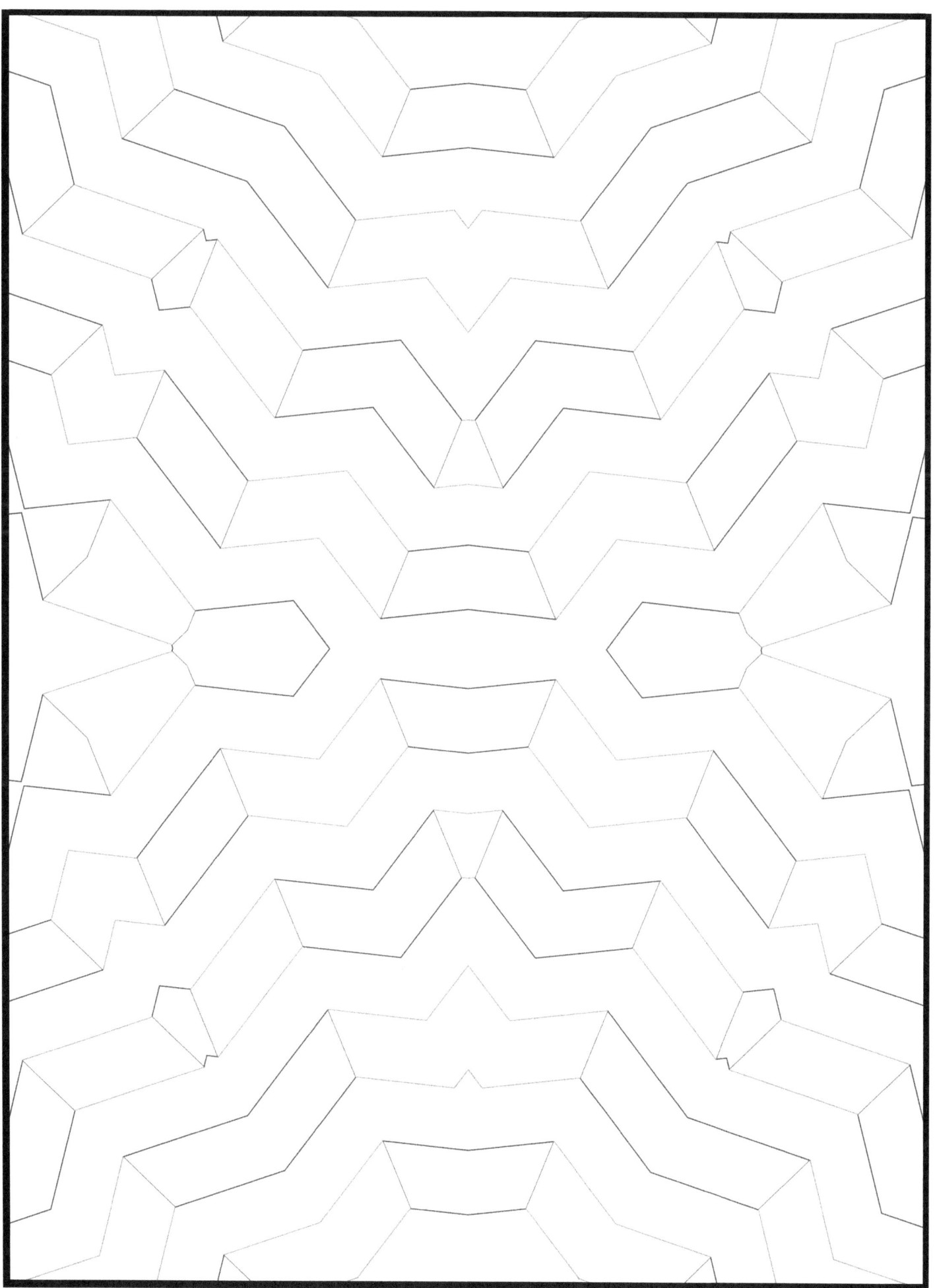

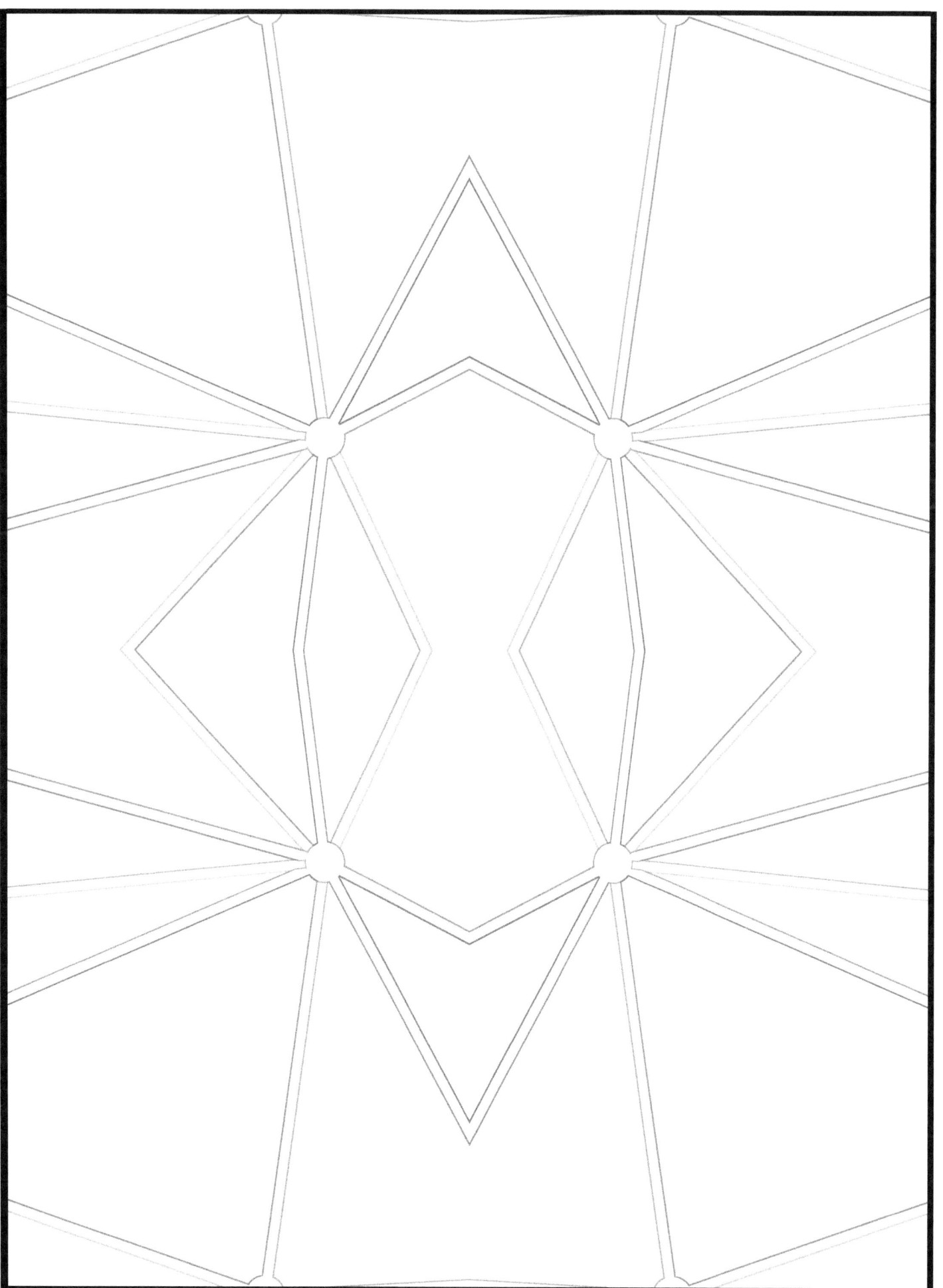

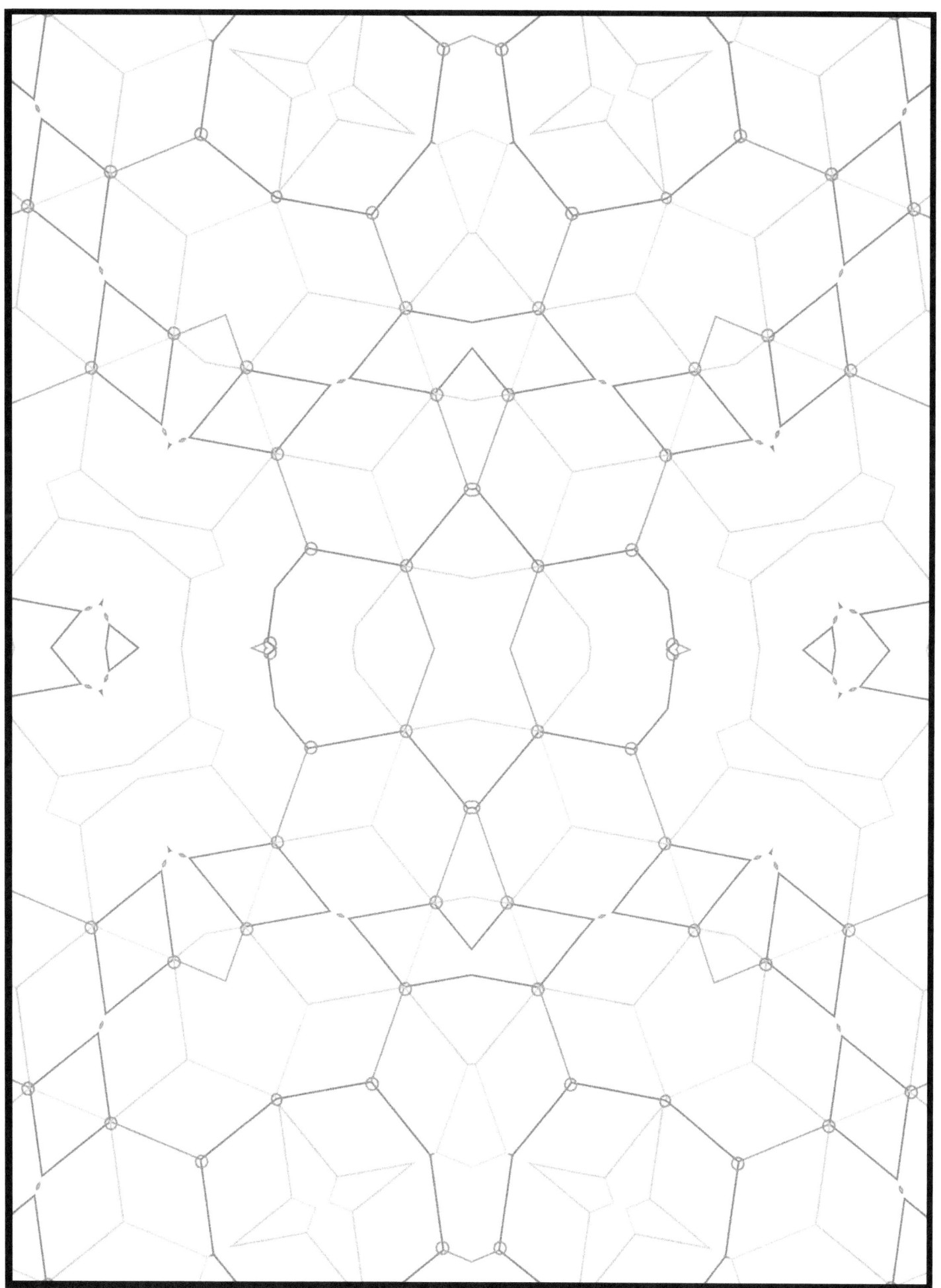

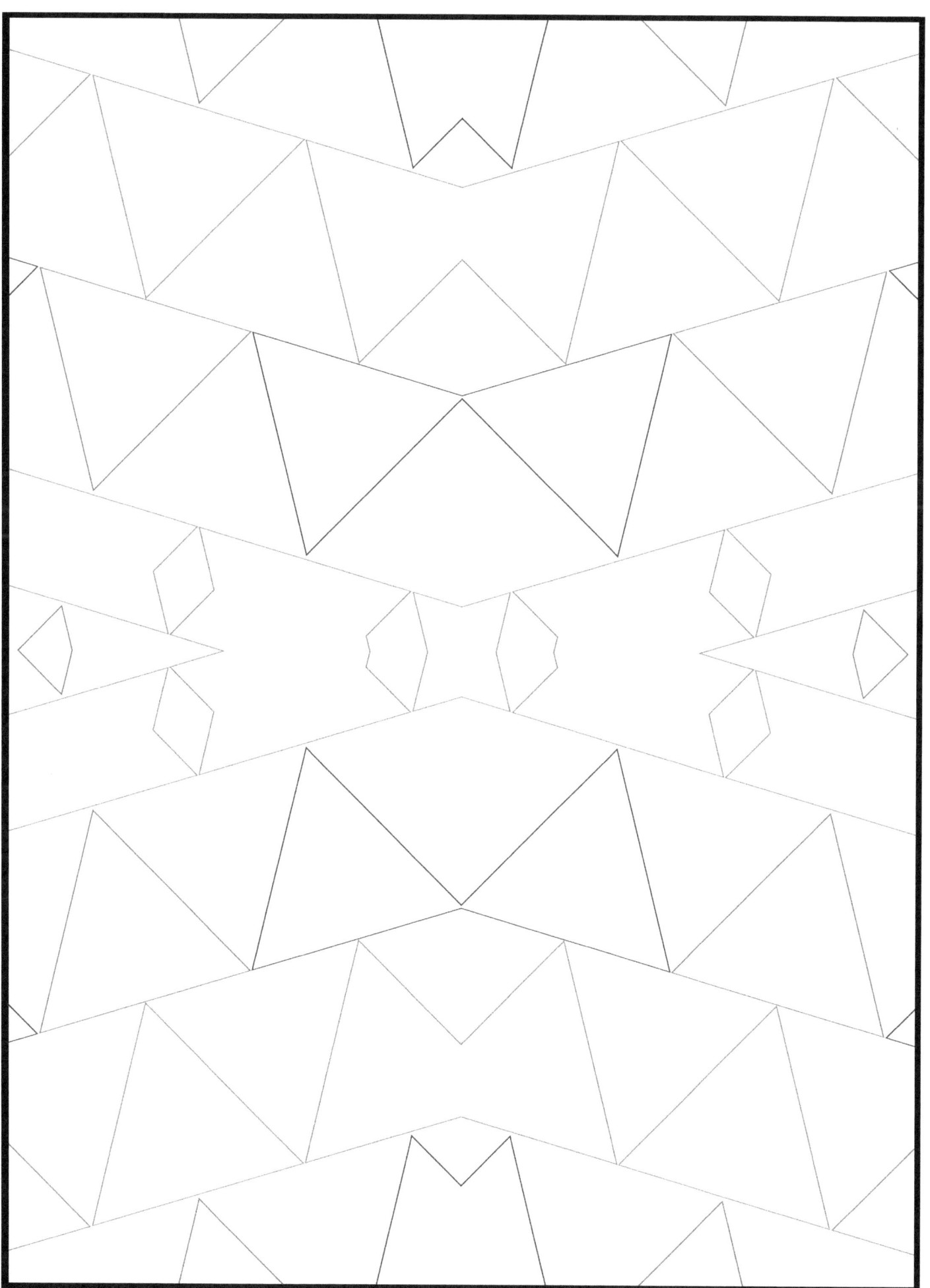

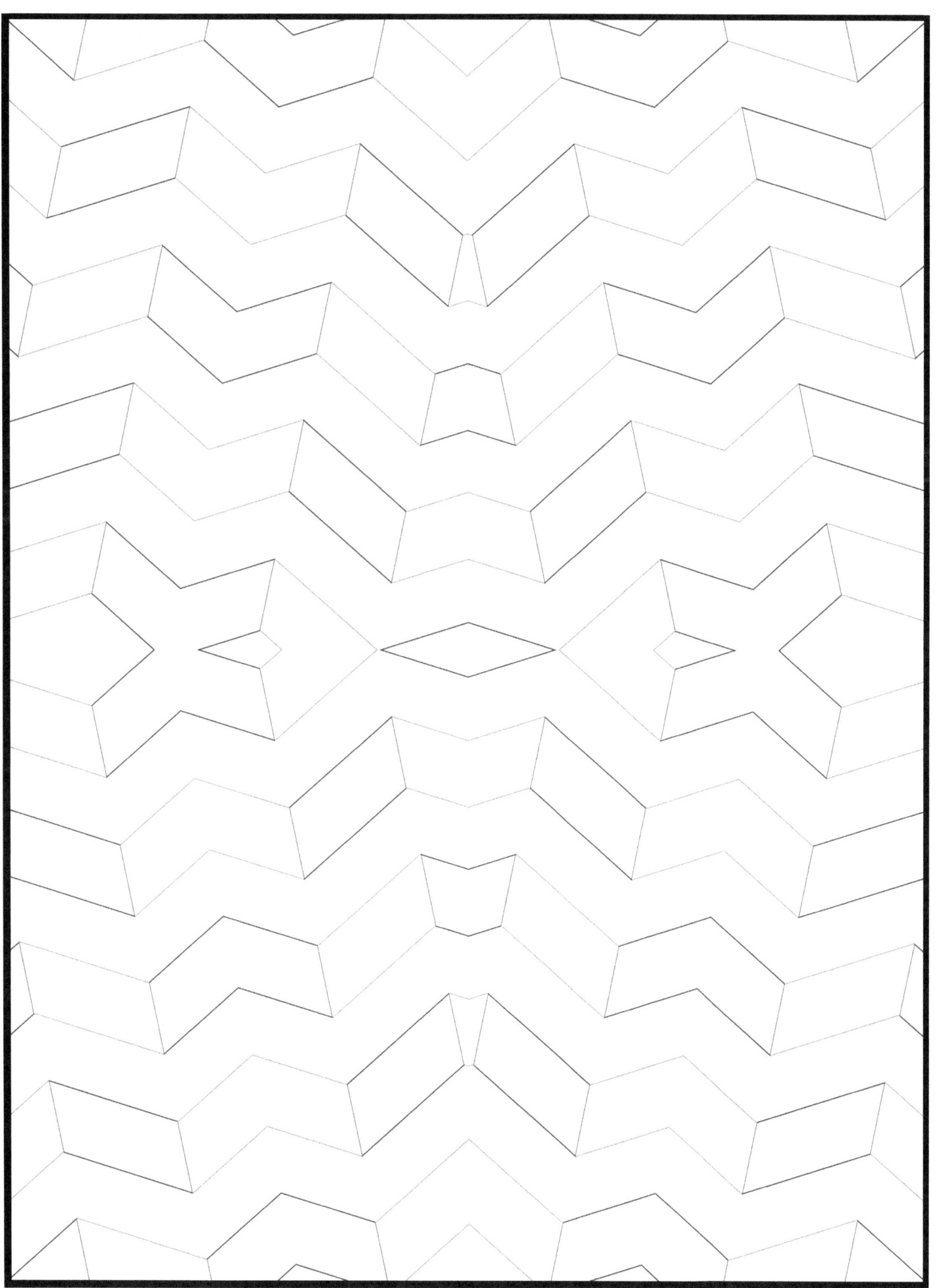

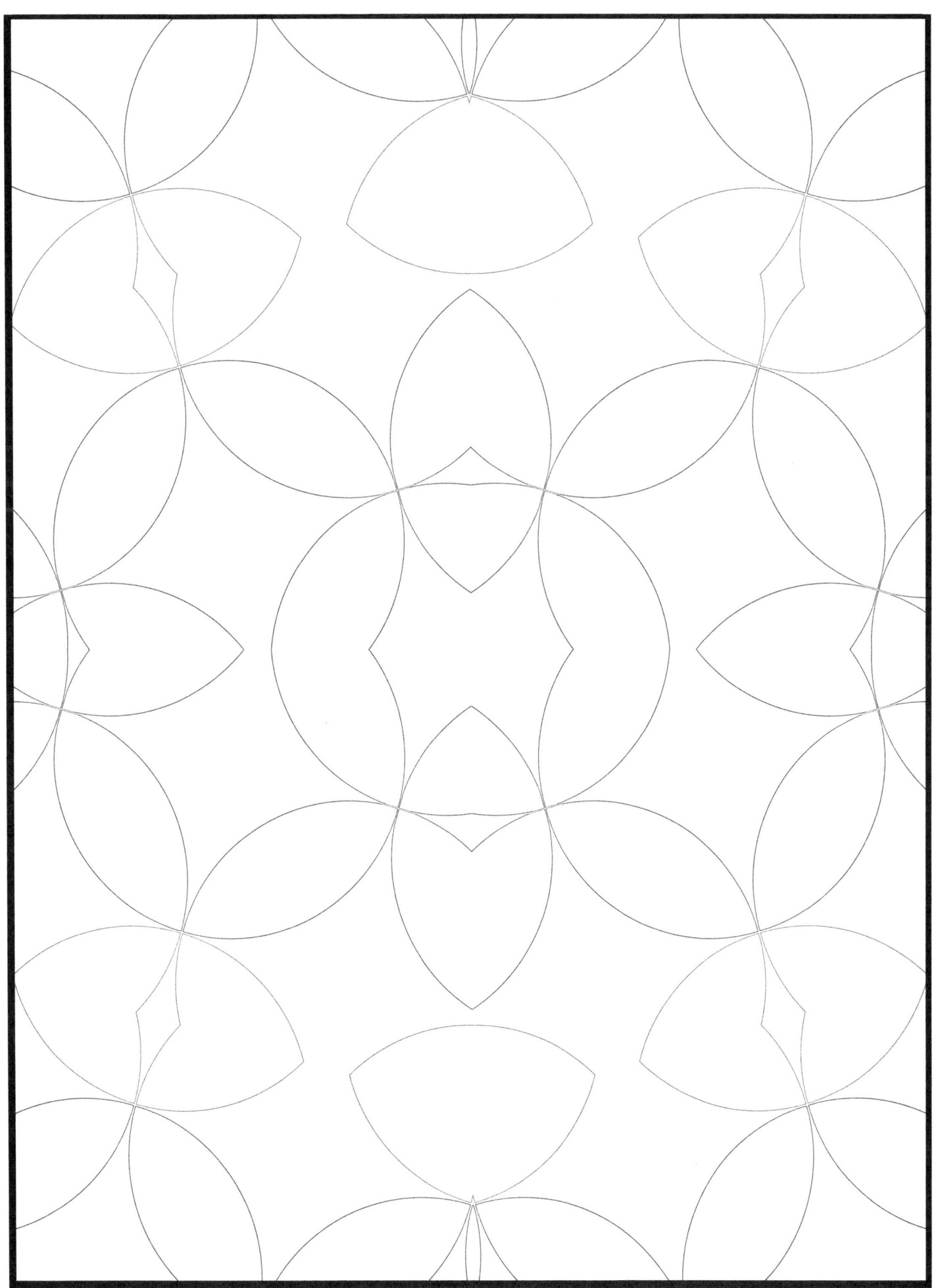

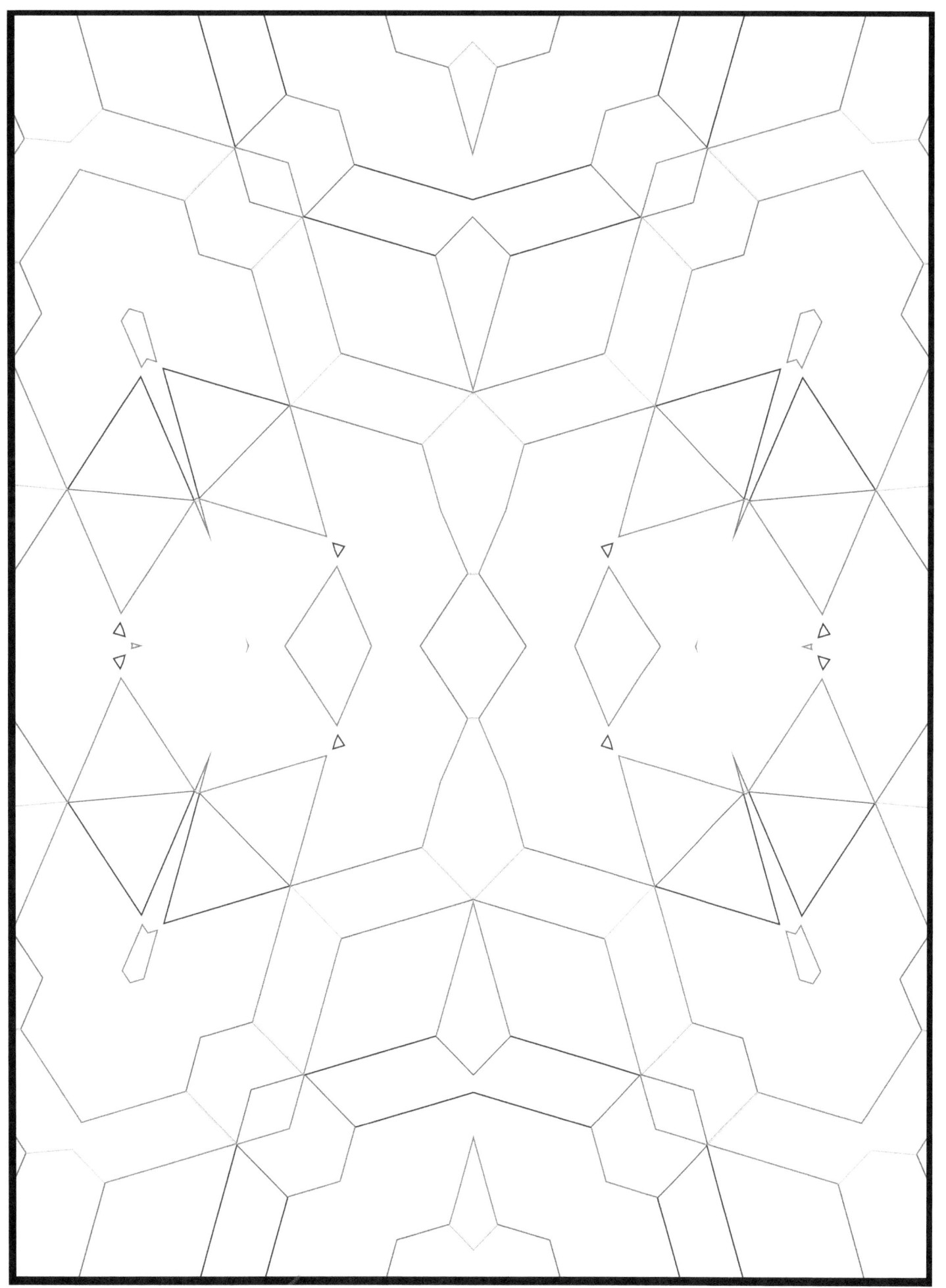

Thank you

Hope you've enjoyed your coloring experience.
We here at **VICTORIA** will always strive to deliver
to you the highest quality coloring books.
So I'd like to thank you for supporting us.

Before you go, would you mind leaving us a review on Amazon?
It will mean a lot to us and support us creating
high quality guides for you in the future.

To get notificate for next new Coloring Books
Please follow our Amazon Author Page.

Warmly yours,
VICTORIA Team

www.ingramcontent.com/pod-product-compliance
Lightning Source LLC
Chambersburg PA
CBHW060015210526
45170CB00018B/3031